FRANKLIN WATTS
LONDON•SYDNEY

Did you know
your head would
fit into the eye-socket
of a *T. rex*?

Dinomania

Welcome to the world of dinosaurs.

Dinosaur ID

- 6 Here's a dinosaur collection to rival the best museum! Learn the dinosaurs' names, check out their sizes and when they lived.
- A Journey through Time
 Create a time chart and map out the millions of years
 when dinosaurs ruled the Earth.
 - Make Your Own Dinosaur Park
 Give your dinosaurs some places to live by the Jurassic seashore, in a moonlit forest, or in a desert nesting colony.
- Pterosaur Mobile

 Here's a mobile made up of flying dinosaurs. Hang it in your window and scare some of today's birds!
 - 18 Dinosaurs on the Move
 Imagine you are surrounded by herds of migrating dinosaurs.
 Play this car game and see how many dinos you can spot.

Check out a Predator

- 20 Get your facts sorted about *T. rex* and other meat-eaters. Feed a *T. rex* too, and get your friends to squidge his stomach yuk!
 - 22 Check out a Herbivore
 Now it's the turn of the plant-eaters. Find out all the details, including why some dinosaurs swallowed stones!
- 24 Dinosaur Dressing Up
 Why not become a dinosaur? You can transform yourself into a raptor, Stegosaurus or Triceratops with these costume ideas.

Cavan County Library Withdrawn Stock

Hunting! Slashing! Tearing!

It's scary being a plant-eater. There are lots of predators wanting to eat you. You have to tread very carefully...

Hide and Seek

30 How did predators track down their food? And did their food ever fight back? Play these two games and find out more.

Dino Dung!

Fancy some dinosaur droppings for tea? A dung beetle certainly wouldn't say no.

Cracking Eggs!

Dinosaurs hatched out from eggs. Make some dinosaur eggs and crack them open!

Dino Dig

Become a palaeontologist – a dinosaur expert!

And excavate your own dinosaur fossils.

Mammal Hunters

Mammals were small mouse-like creatures when dinosaurs ruled the earth – and a tasty snack for a hungry *Troodon...*

The End of the Dinosaurs

Why did the dinosaurs die out? A volcano explosion?

A meteorite hit? Decide for yourself with these activities.

Dino Performances

Put on a dinosaur play! Perform a dinosaur dance!
Or scare all your friends with sounds in the dark...

Make Your Own Dinosaur Video

46 Bring all your dinosaur knowledge and activities together in an action-packed, gore-splattered movie!

Dinomania

If you visit a natural history museum today, you can see massive skeletons of fossilised bones. You probably know what they are, but long ago when people first found these huge bones they thought they were the remains of dragons turned to stone! Then about 150 years ago, scientists worked out that these 'stone bones' belonged to something much more

exciting – dinosaurs!

In the Beginning

Life on Earth began about 3800 million years ago – that's almost too long to imagine, but let's try! For the first 3440 million years life was made up of tiny creatures – no bigger than specks of

dust. Then these microscopic life-forms began to change, or evolve, into all sorts of different animals and plants – shellfish, squids, plants, insects and fish (the first animals with backbones).

About 360 million years ago, the first animals moved from the water on to land. Gradually, taking millions more years, they changed into even more species of animal of every shape and size, adapting to life in and out of the water. In the seas, there were massive sea reptiles. On land, breathing air, there were frogs, lizards and crocodiles. And then there were

DINOSAURS!

The World of the Dinosaurs

The dinosaurs and sea reptiles were some of the largest animals that ever lived. The world they lived in was very different from ours — there were no humans for a start!

Dinosaurs roamed across endless deserts of blowing sand, scavenged along the seashore, splodged through swamplands and lurked in forests of pine, fern and monkey puzzle trees.

Discover the dinosaurs' world and recreate it as well with the activities in this book. Have fun being a dinomaniac!

Dinosaur means 'terrible lizard' in Greek. It's the name we give to a group of animals that lived on earth millions of years ago.

Look out for these 'fact bites' through the book.

Dinosaur ID

Here are just some of the different types of dinosaurs and sea reptiles you'll be getting close to in this book (but don't get too close!). This ID chart says what they ate, when they lived and how big they were. Watch out for them on your dinomaniac's adventure.

Plesiosaurus
Marine reptile • Fish~eater
• Jurassic • 12 m long

Protoceratops Plant~eater • Late Cretaceous • 1.8 m long

Triceratops
Plant-eater • Late Cretaceous
• 10 m long

Ornithocheirus Pterosaur

- Fish~eater
- Early Cretaceous
 - 8 m wingspan

Oviraptor Egg~eater

- Late Cretaceous
 - 2 m long

Stegosaurus
Plant-eater
• Late Jurassic • 7 m long

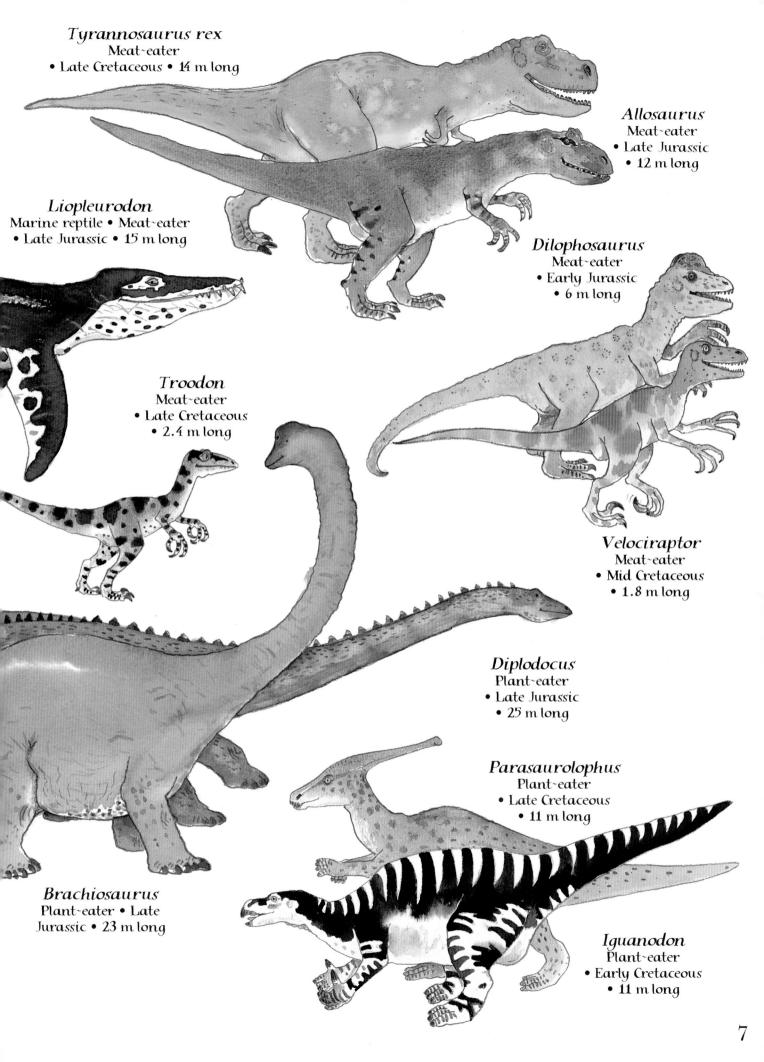

A Journey through Time

Earth has existed for such a long time that people have divided the past into time periods and given them names like Jurassic and Cretaceous. Each period lasts for millions of years. The time period we live in now is called the Cenozoic. It began 65 million years ago!

Take a long piece of wallpaper and spread it out on the floor. Work on the back side.

Draw a line along the bottom of your paper and mark it off into sections like the ruler below. The numbers mean millions of years, so keep them big.

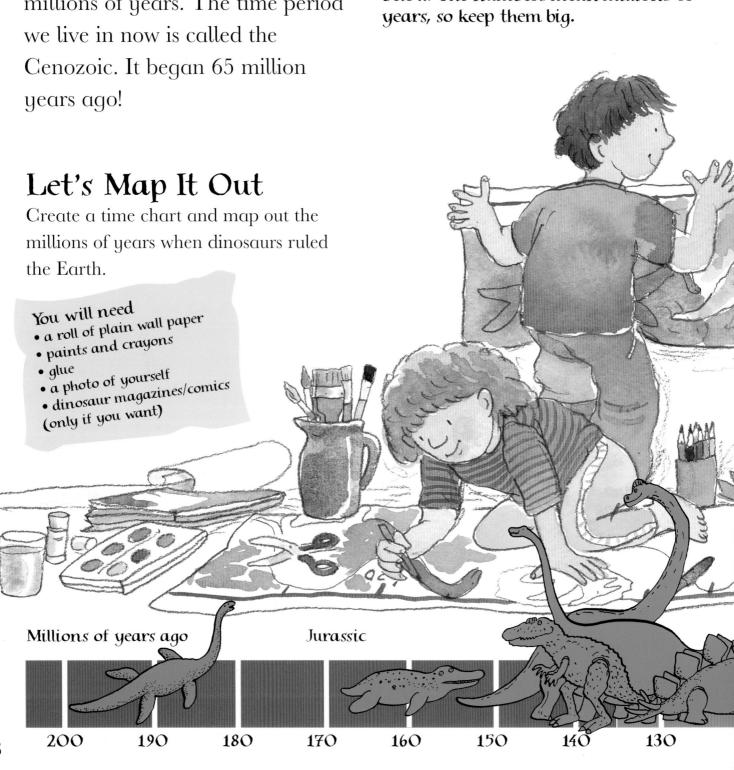

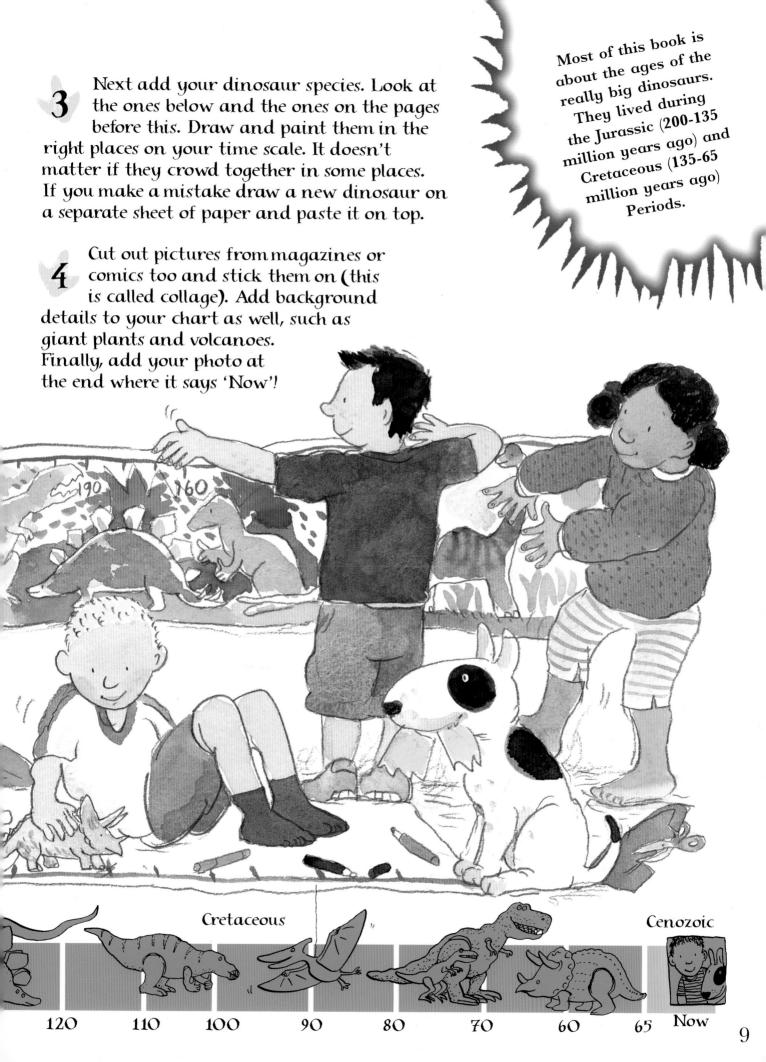

Make Your Own Dinosaur Park

Give your dinosaurs a place to live and welcome your friends to 'Dino World'! If you don't have any toy dinosaurs to live in your dinosaur park, you can make them out of cardboard; copy the dinosaur shapes on pages 6 and 7 and stand them up with a tab like the cacti on page 15.

By the Seashore

Where the Jurassic sea touched the land, there was always something to eat. The stink of dead animals washed up on the beach brought dinosaur scavengers, while shoals of fish swimming close to the shore attracted marine reptiles. In this dangerous place, all sorts of adventures happened...

Cut away two sides of the box and its lid like this (keep the card you cut away).

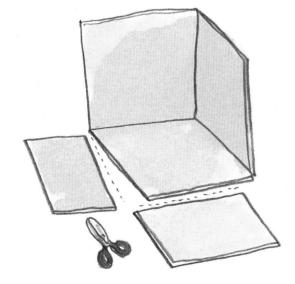

You will need: •large cardboard box

· paints

scissors

 large see-through plastic 'bin' bag (or carrier bag)

glue stick or PVA glue

• cup of clean sand

· an old sponge

· pebbles and small shells

Paint the box to create a rocky beach on the bottom, cliffs behind and volcanoes in the background.

When the paint is dry, smear the beach with glue and scatter a handful of sand over it. Shake it off onto newspaper:

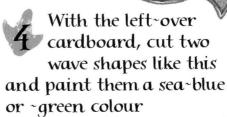

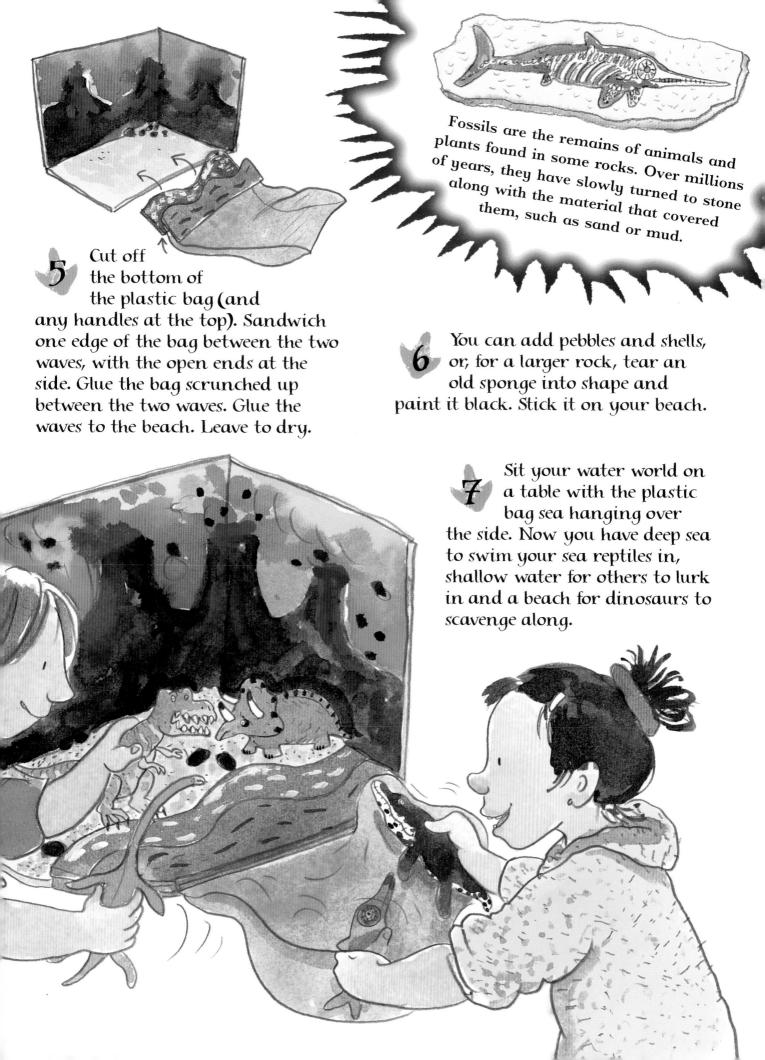

Moonlit Forest

Imagine a forest by moonlight. Insects are singing. Plant-eaters are chomping while predators creep around ready to rip and eat their flesh!

You will need:

- large cardboard box
- paints
- blue or green plastic bags
- strong tape
- black plastic 'bin' bags
- glue scissors
- glitter
- pocket torch

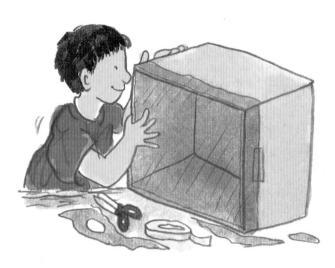

Cut away the back of your box so you have a four-sided frame. Paint the insides black.

Cover the back of the box with a large piece of plastic bag. Tape it into position.

Cut tree trunk strips from the spare cardboard. Cut slits in the top of the box and slip the trunks through. Stick them in position and paint them.

slopes.

Hang torn strips of bin bag from the top the box to make the forest look deep, dark and mysterious.

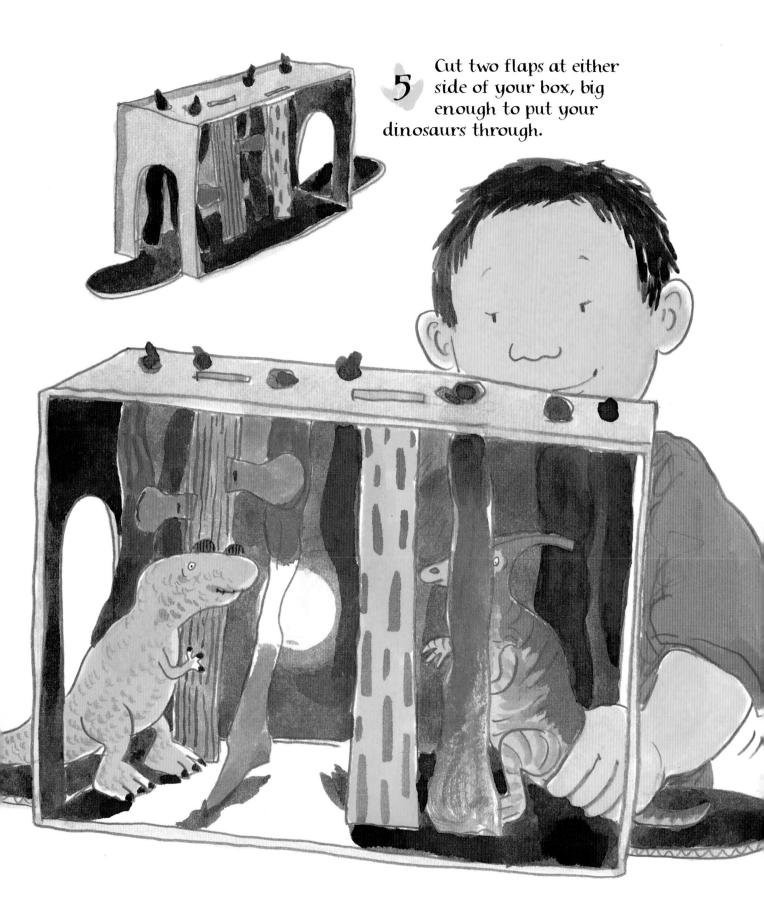

Sprinkle silver glitter dust around the floor and branches and add some dinosaurs. Invite your family or friends to come and watch. Turn off the lights and switch on your torch. Shine it through the plastic at the back to give an eerie, moonlit effect. Make some dinosaur growls and roars as sound effects.

Nesting Colony

For plant-eating dinosaurs, there was safety in numbers. Many dinosaurs, including *Parasaurolophus*, *Maiasaura* and *Protoceratops*, nested in colonies. But a nesting colony was also a perfect place to find an egg-thief like *Oviraptor*.

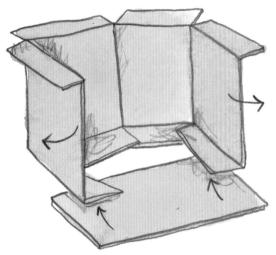

Open the bottom of a large box and then cut down one side to open out the box. Use extra cardboard to make a solid base and paint it a sandy colour. Paint the sides a blue sky colour.

2 Squidge some loo paper together with some PVA glue (wear some old washing up gloves or your hands will get very sticky) and mould it into nest shapes. When they're dry, paint them a sandy colour too. Stick them in place

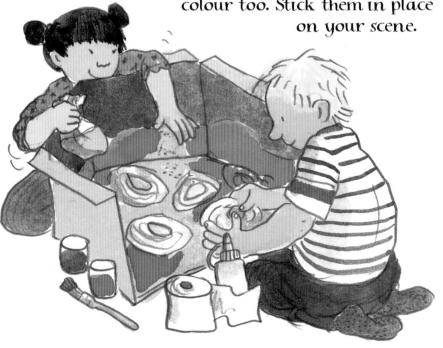

Dab PVA glue around the scene and sprinkle sand on it. Shake off any loose sand onto newspaper:

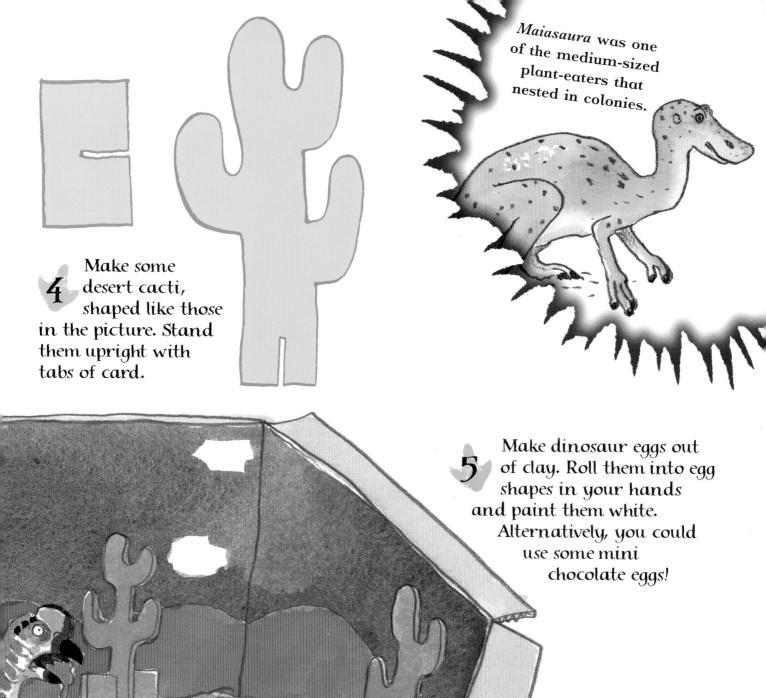

Add your dinosaurs and make some spy holes low down around your box. Now you can get dramatic close~up views of your nesting dinosaur colony's activities without frightening them!

Pterosaur Mobile

Pterosaurs were flying dinosaurs. Just like today's birds, there were different types. There were huge ish-eaters like Ornithocheirus and smaller species like Rhamphorhynchus. They may have cried like seabirds, cooed like doves or squawked like parrots! Hang this oterosaur mobile in your window and give today's pirds a shock!

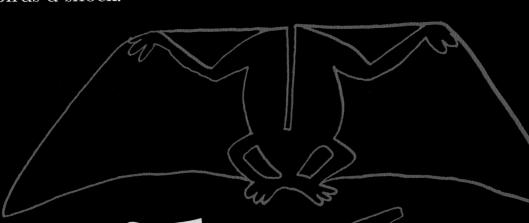

You will need

- cardboard (the sides of a cereal box are fine, but work best if you paint them white first using water based paint)
- paints, crayons and marker
- hole puncher or stapler
- fishing line or string

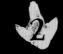

Draw in the details on each piece of card - or just paint them bright colours. Slot the pieces of card together as shown.

You can copy the shapes shown nere or, better still, draw your own.

Attach the string to the neck of each one. You can use a hole puncher or a stapler:

Manneman

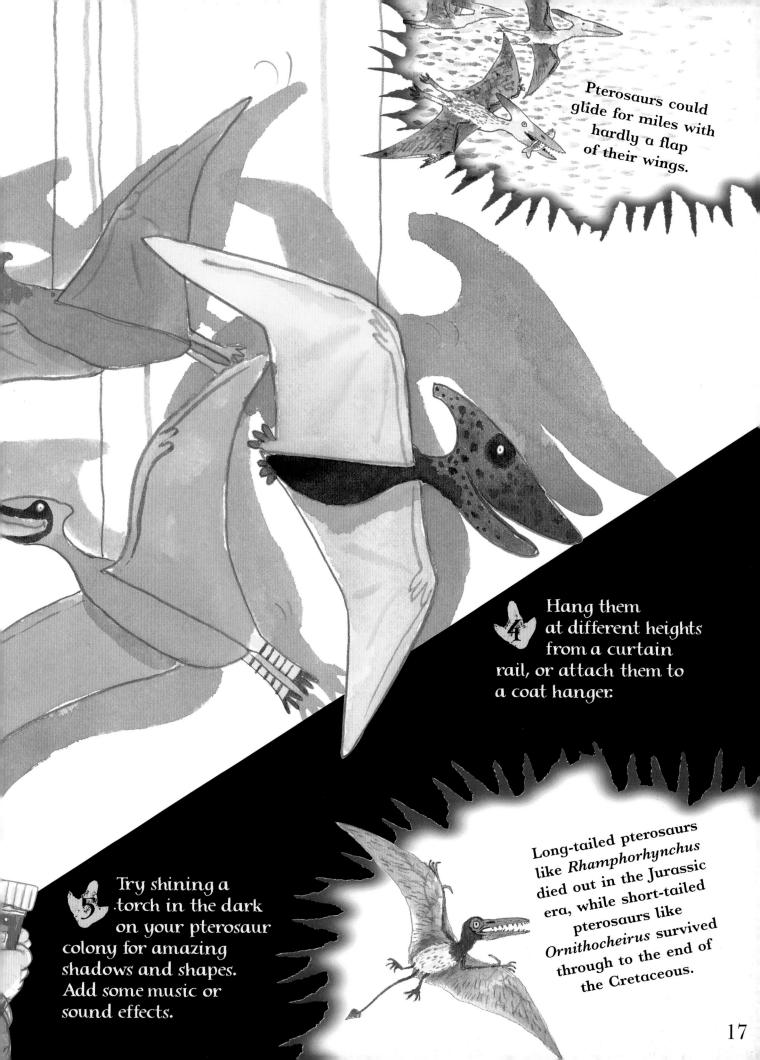

Dinosaurs on the Move

Many species of dinosaur like *Iguanodon* and *Parasaurolophus* are believed to have migrated – travelled huge distances in search of food. They travelled in vast herds just like the zebras and wildebeeste of Africa today. And just like the lions you see on TV documentaries, there were predators like *Velociraptor* and *T. rex* waiting to ambush them!

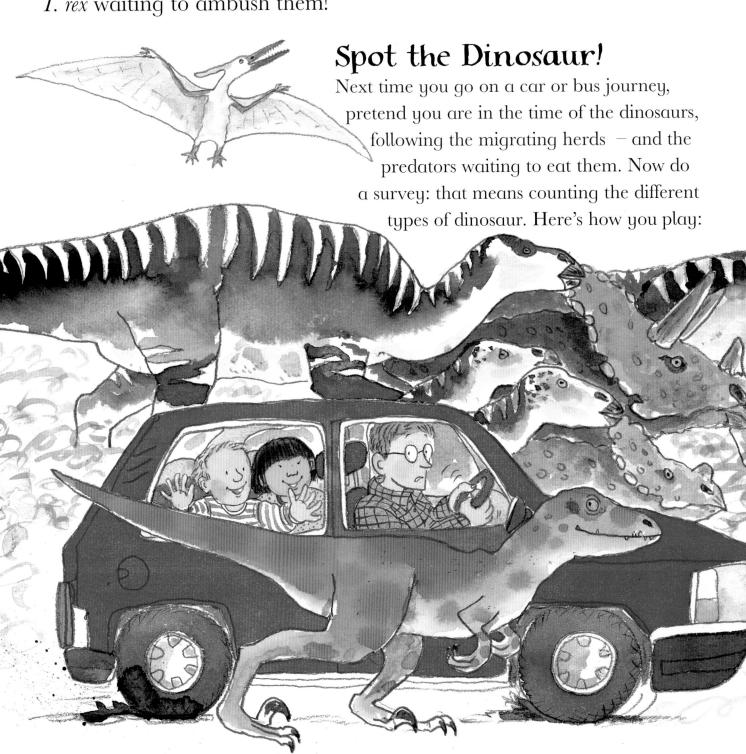

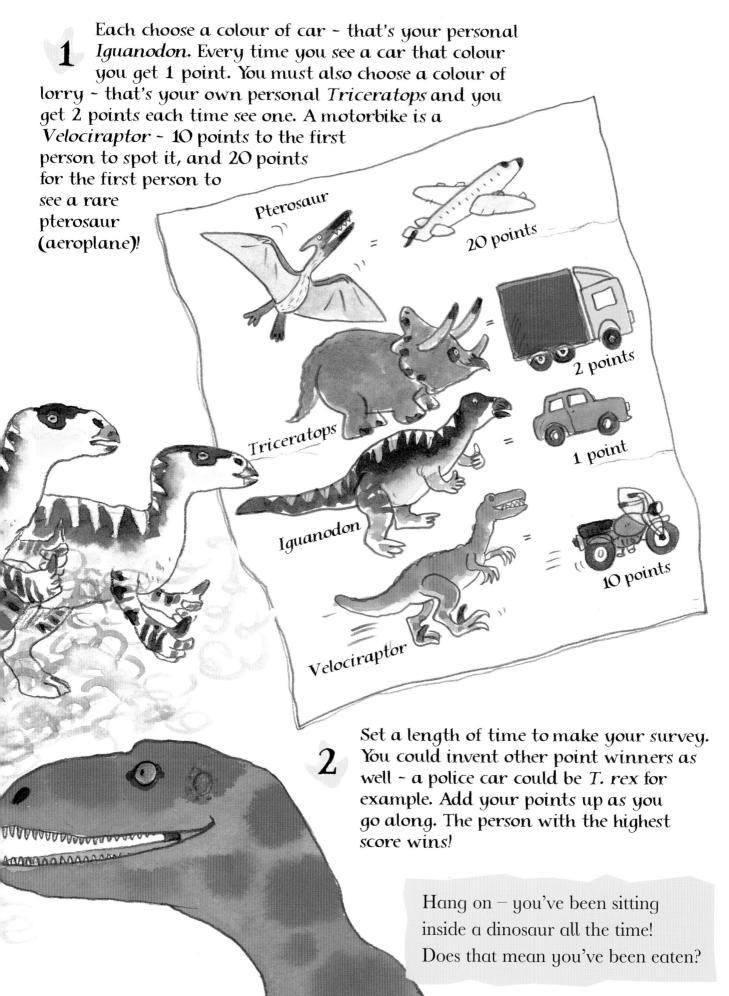

Check out a Predator

Dromiceiomimus
and some other
predators ran faster
than an ostrich at
65 km/h.

Dinosaur predators were experts at catching and eating meat! *Dromiceiomimus* caught insects and lizards while *Velociraptor* hunted in packs, preying on other dinosaurs. But they shared many features with the giant predators — dinosaurs like *Allosaurus* and *Tyrannosaurus rex*!

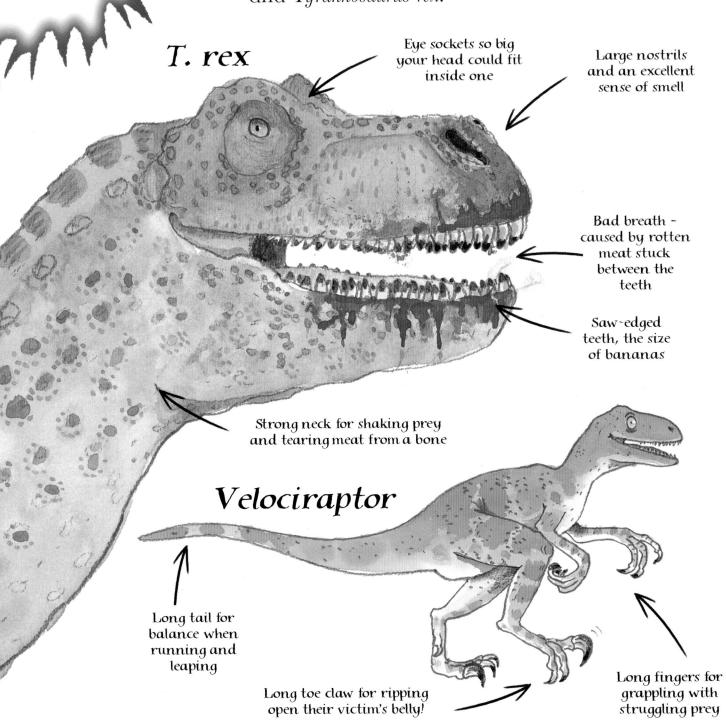

Feed a T. rex

Predators had strong stomachs to help them digest lumps of raw meat and bone. Feed this T rex

- card
- scissors
- paint and crayons
- small plastic bag
- gory ingredients (e.g. bread, tomato sauce)
- sticky tape

bigger than T. rex.

Colour in one side to look

like a T. rex and paint the other side black. Leave it to dry.

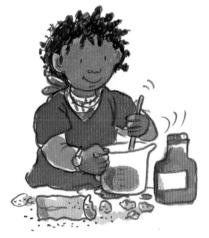

Take a small plastic bag and fill it with tomato ketchup and chunks of bread - or ketchup~covered spaghetti! Secure it tightly with sticky tape.

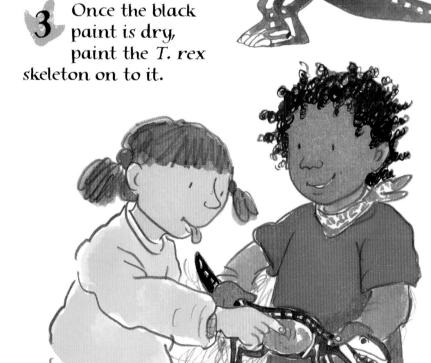

Tape the plastic bag onto the skeleton - where its stomach should be. Now dare your friends to squidge a T. rex's stomach - blahh!

Check out a Herbivore

Herbivores varied in size and shape depending on what they ate. Just because they ate plants doesn't mean they were timid or 'easy meat'. Many were strong and aggressive – both to predators and to each other, when fighting

Stone Swallowers

for territory or a mate.

The larger herbivores like Brachiosaurus ate huge amounts as much as 1500 kg of food every day. Many herbivores swallowed stones and pebbles to help them break up their food. Try this experiment to see how it worked.

You will need smallish plastic bottle

- · leaves, twigs, small
- pine cones • small stones/gravel

Crest may have worked like a trumpet to make loud warning calls

Brachiosaurus

Long neck to reach the highest branches

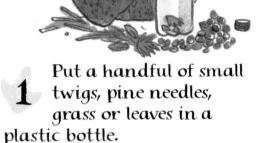

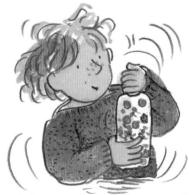

- Add a little water and a lot of small stones. Put the cap back on and shake hard for a few minutes.
- Shake as long as you can and pour it out. The soup you make is a bit like what happened inside Brachiosaurus' belly!

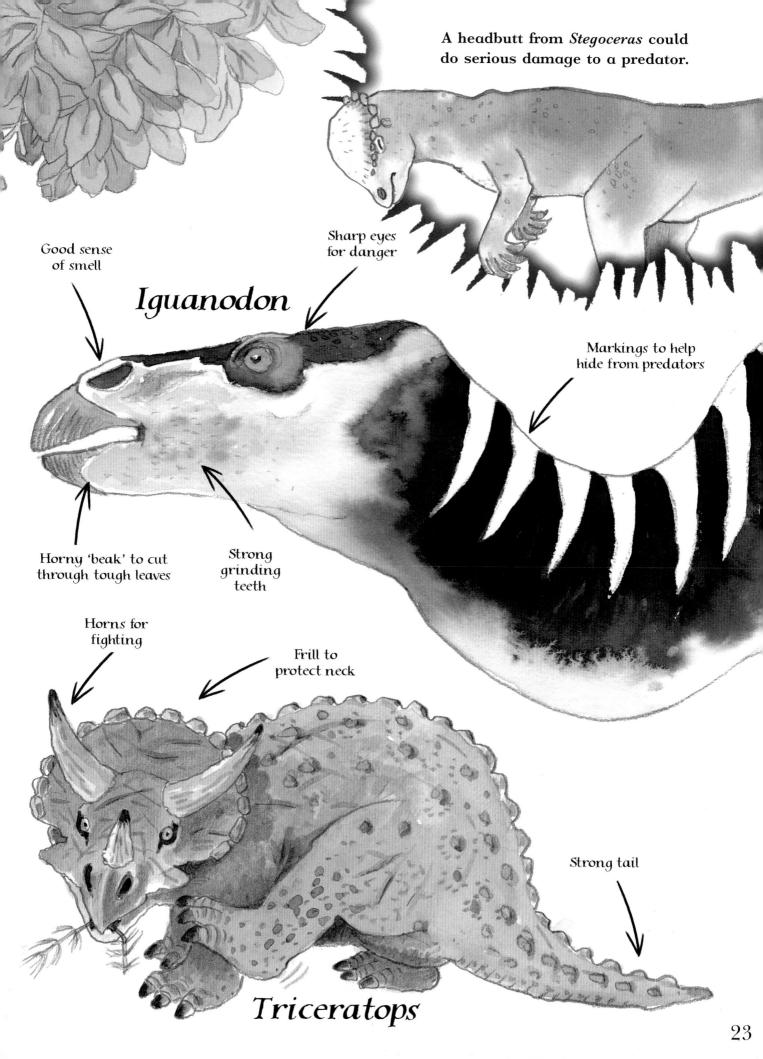

Dinosaur Dressing Up

Dinosaurs came in all shapes and sizes, each one adapted to a particular skill. Some had sharp teeth for tearing flesh from bones. Others had long necks to reach the best leaves in the thick forests! Would you choose a razor-toothed raptor, a spiky-backed Stegosaurus or 'rhino'-like Triceratops? Turn yourself into a dinosaur with these costume ideas.

Make a Raptor Costume!

- Some bubble wrap
- A cardboard box (to fit over your head)
- Some card
- Paints

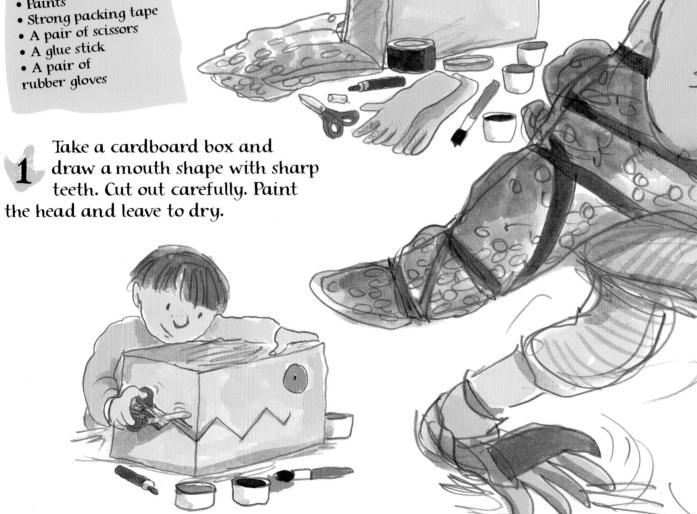

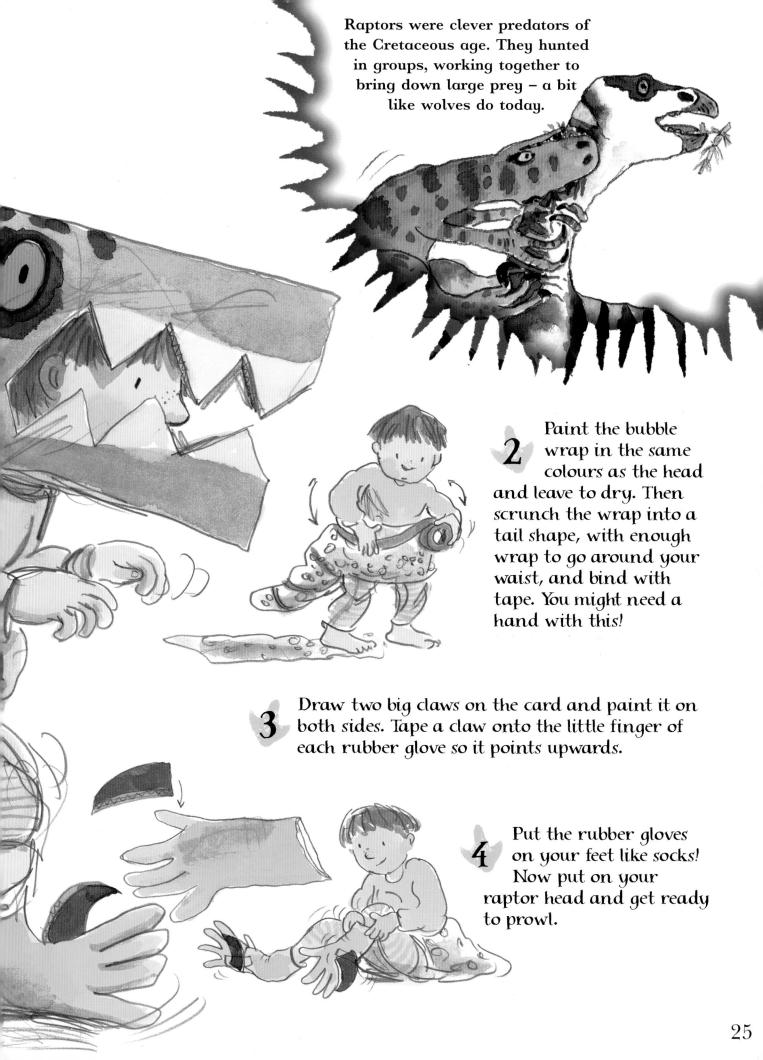

Stegosaurus

The bony plates of a *Stegosaurus* could probably change colour (a bit like a chameleon's skin), perhaps to threaten a predator or attract a mate. Stegosaurus was strong and could use its tail to injure or even kill a predator.

You will need:

- cardboard
- paints
- scissors
- an old coat or shirt
- an old baseball cap • a stapler

Cut out plate shapes like this from card and paint them your favourite colour.

26

Cut out and paint the tail (see the shape above).

Cut slits in the back of an old coat or shirt. Poke your plates through the slits and fold upright. Staple them in position.

Paint an old baseball cap to match the plates and draw some eyes on it.

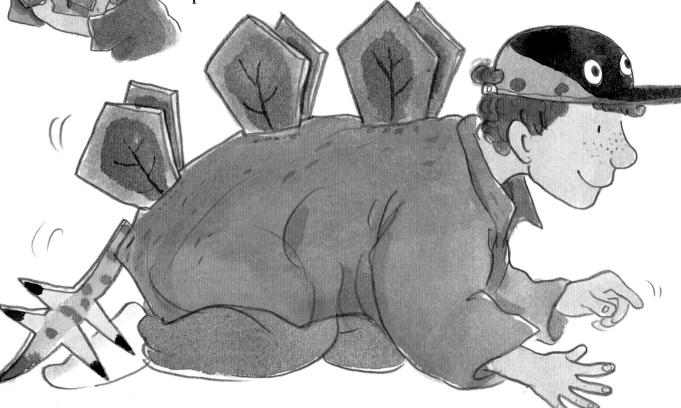

Triceratops

The 'rhino' of the later Cretaceous, *Triceratops* was strong and aggressive – and not to be messed with! Even *T.* rex had to take care.

- cardboard
- scissors
- string
- · paints

Use a large piece of cardboard and cut out these shapes, basing the measurements on the size of your neck, shoulders and head!

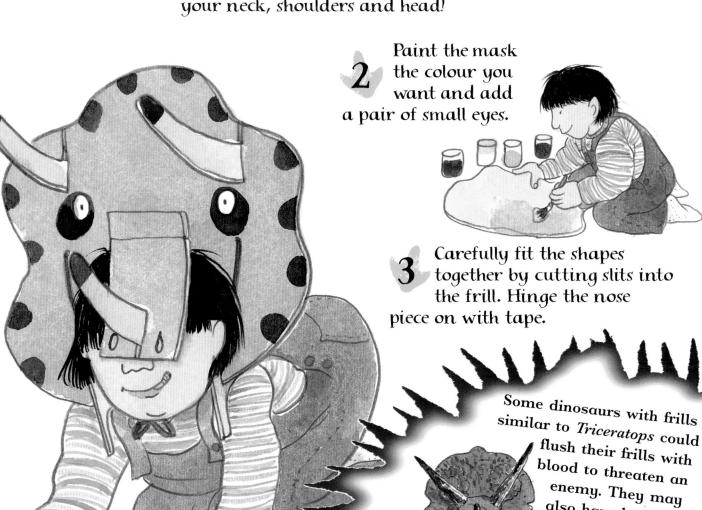

27

also have had eyeshaped patterns to make themselves look bigger – like peacocks and moths do.

Hunting! Slashing! Tearing!

Fossils can tell us how dinosaurs moved, lived and fed. They show that *Velociraptor* slashed its prey with a huge toe claw so it bled to death. The plant-eaters had to be careful!

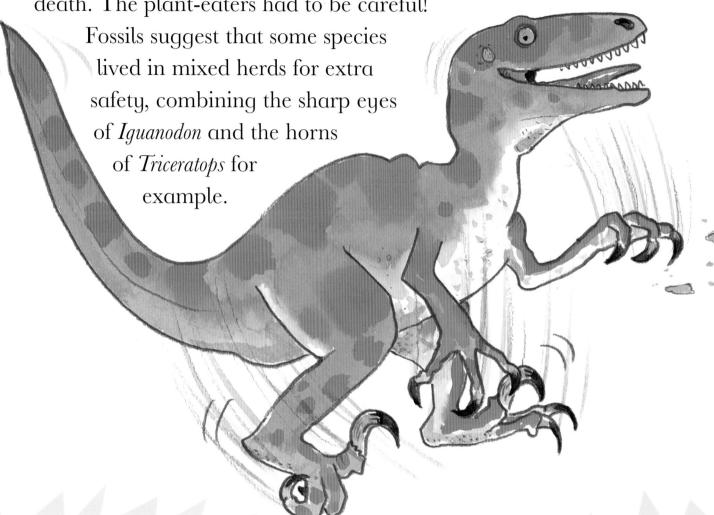

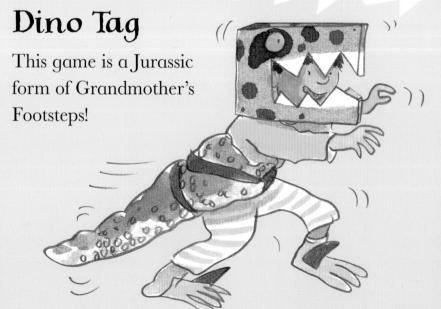

- Wear your herbivore costumes or masks and follow the predator until he decides to turn and grab you.
- Be ready to run!
 Whoever is touched first has to sit down until all the herbivores have been caught then it's time to play again.

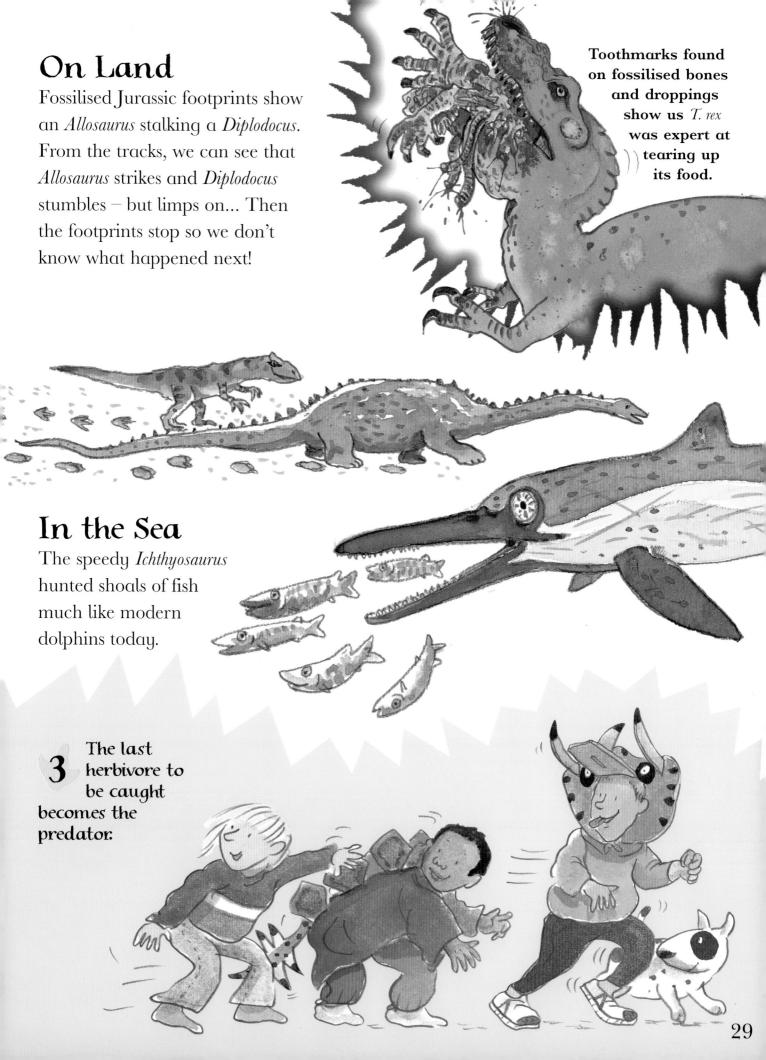

Hide and Seek

We can guess how meat-eaters caught their prey by looking at modern predators — *T. rex* may have hunted *Triceratops* like a tiger ambushes deer at a waterhole. An *Allosaurus* pack probably hunted *Diplodocus* like hyenas hunt zebra, working together to separate a sick or young animal from the protection of the herd.

Hunter and Prey

Velociraptor hunted using its speed and its good nose, eyes and ears. It was a clever hunter, preying mainly on smaller plant-eaters. Play this hide-and-seek game.

- One of you is Velociraptor, the rest of you are newly hatched plant-eaters.
- The plant-eaters hide and the terrible Velociraptor seeks you out.
- 3 Take turns being Velociraptor.

A fossil

Velociraptor was
found still clutching
a Protoceratops. It's
a mystery why they
died together...

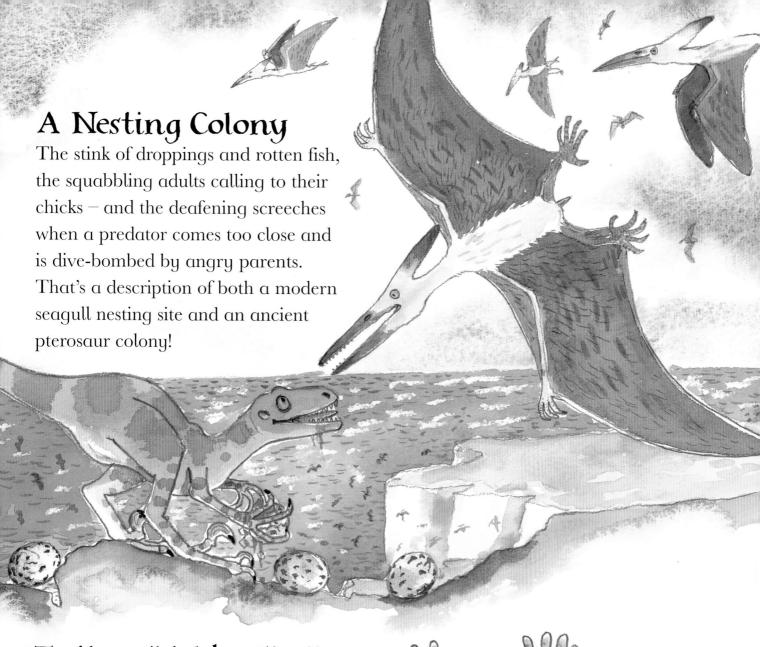

Teeth • Shield • Skull

This is a game for two people, which you play like 'Scissors, stone, paper'.

Both put your hands behind your back.

After a count of three bring one hand out each, choosing one of the three dinosaur hand signals shown. Whoever has the 'stronger' hand signal wins.

Play the best of ten games.

Velociraptor eats Protoceratops

Protoceratops' shield beats Stegoceras

Stegoceras butts Velociraptor

Dino Dung!

Droppings help plants to grow, but first they have break down to become part of the soil. One animal that helps this happen is the

dung beetle: modern ones bury elephant

droppings – Jurassic ones buried dinosaur droppings. They had a lot of work to do, since just one dropping from a *Stegosaurus* would fill a wheely bin!

Droppings Delight

Make some dinosaur droppings for tea and chomp them up just like a dung beetle grub! You will need:

- a saucepan
- heat-proof bowl
- chocolate bar
- approx. 1 cup of muesli

Break the chocolate into the bowl and place it over a saucepan of very hot water until the chocolate melts. (NB Ask an adult to help you with this.)

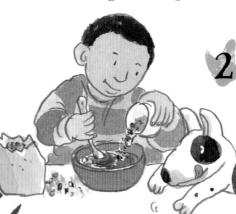

Stir muesli into the melted chocolate until you get a good dung-like mixture.

1. First the dung beetle rolls a golf-ball sized lump of dung.

2. Then it rolls it to a suitable spot and buries it with some eggs.

3. The eggs hatch and the grubs feed on the dung as they grow.

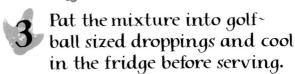

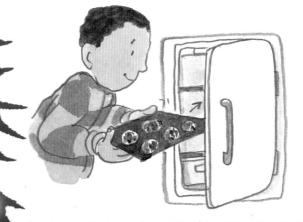

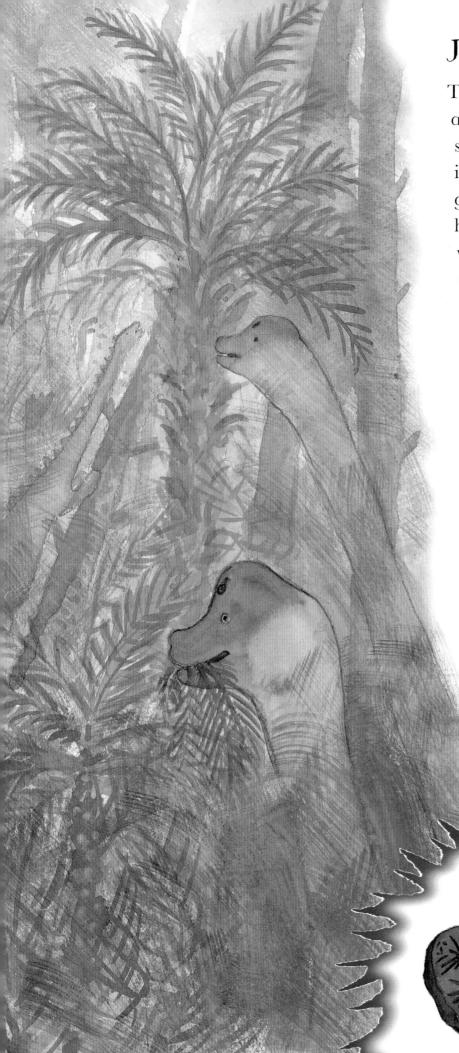

Jurassic Plants

There were many different trees and plants in the Jurassic age; some are still around today including pines and yew trees, giant redwoods, monkey puzzles, huge ferns and cypresses. There were no flowers. They didn't appear until the Cretaceous period, millions of years later. And grass came later still – in the Cenozoic Period.

Sometimes, the sticky resin oozing from the bark of Jurassic pine trees hardened to form a rock-like substance called amber. Insects that had stuck in the resin were preserved in the amber – so we can still see insects from the age of the dinosaurs!

When you touch a lump of coal you are touching the past – the fossilised remains of swampy forests possibly from the Jurassic age.

Cracking Eggs!

Dinosaurs laid eggs – lots of fossilised ones have been found. Most dino eggs had a thick, rough shell. Some were laid in mud nests; others were buried – just like crocodile eggs today. Make some

dinosaur eggs of your own!

- some balloons
- newspaper
- PVA glue mixed with water
- · string
- · paints
- scissors
- · sticky tape

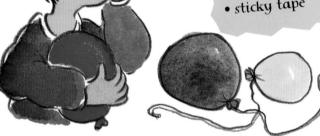

Blow up some balloons to different sizes and tie a string to each one.

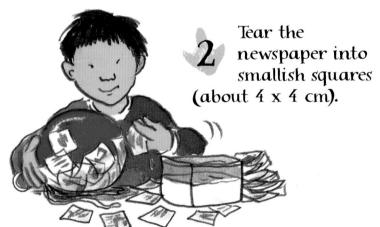

Dip a piece in the glue mixture and stick to the balloon. Repeat this process until the balloon is covered in several layers of papier mâché.

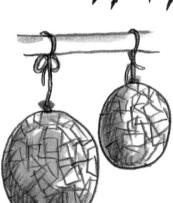

Hang each balloon up by the string and leave to dry in a warm place for 2 days. Then pop the balloon inside with a pin

Paint your eggs - creamy white, pale blue and green or speckled. Choose which dinosaur laid each egg and write a label for each one.

A brand new Triceratops hatches

from its egg.

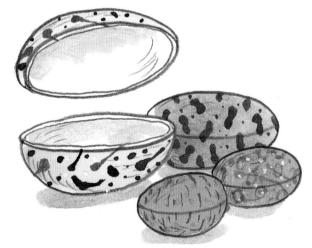

When the paint is dry, carefully cut the egg in half and hinge it with sticky tape. What do you think you could hide inside?

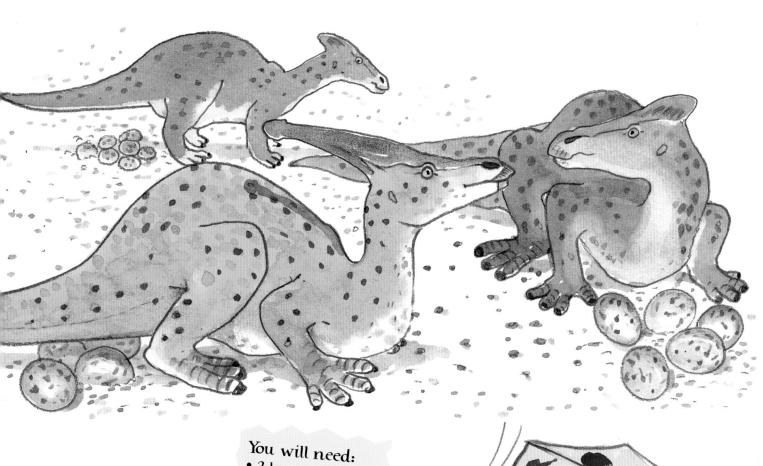

Hatch out!

Parasaurolophus was a plant eater that nested in colonies. It was one of many dinosaurs preyed on by T. rex and Velociraptor. Pretend to be inside a Parasaurolophus egg and hatch out! Use this in your dino performance or video (see pages 44 to 47).

boxes · paints

Make sure you can sit inside one of the boxes, then paint both of them like a spotty egg.

> Climb into your egg and hold the second box over your head.

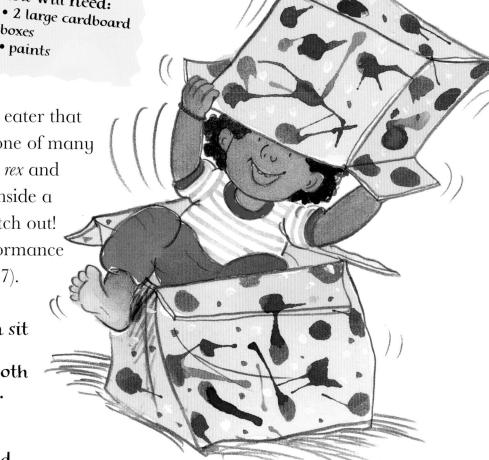

Make some squeaky calls to your dinosaur mum, lift the box and crawl out. Get ready to run, though - a predator may be waiting! Dino Dig

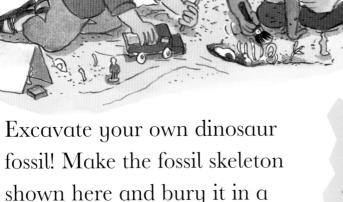

box of sand. Use a small spoon

away the sand, very carefully.

and a paintbrush to brush

Dino skeleton

Use pipe cleaners to copy this skeleton (or invent your own). Cut shorter lengths for feet, ribs, etc with scissors. Use one pipe cleaner as a temporary hanger.

Hint:

If you can't find pipe cleaners, cut out simple bone shapes from cardboard and dip these in plaster of paris instead.

Wearing old clothes and rubber gloves, mix up 3 cups of plaster of paris to 1 cup of water in the old plastic bowl.

You will need:

- pipe cleaners
- scissors
- old plastic bowl
- rubber gloves
- plaster of paris
- newspaper

Holding your skeleton by its hanger, dip it in the mixture.

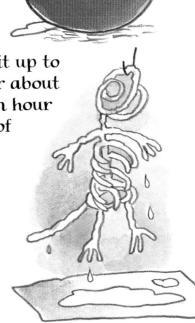

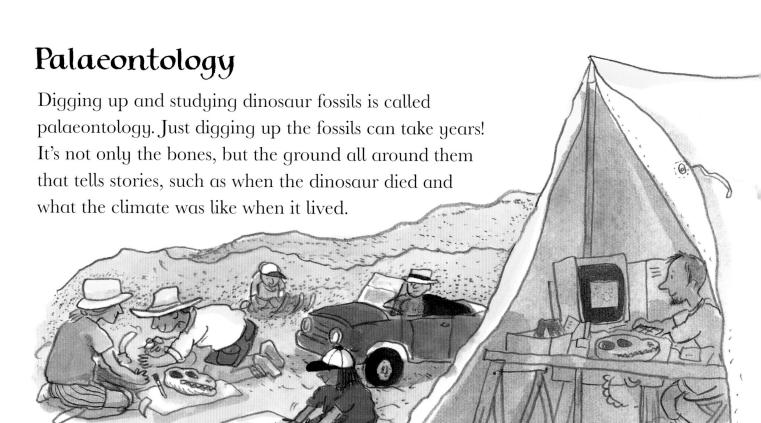

When a fossil is

the rock around it excavated.

discovered, its position is carefully recorded and

At the lab, the skeletons are cleaned and the long process of study begins....

Some of the best skeletons are displayed in museums.

The bones are wrapped up in plaster of paris bandages for protection and transported back to the lab.

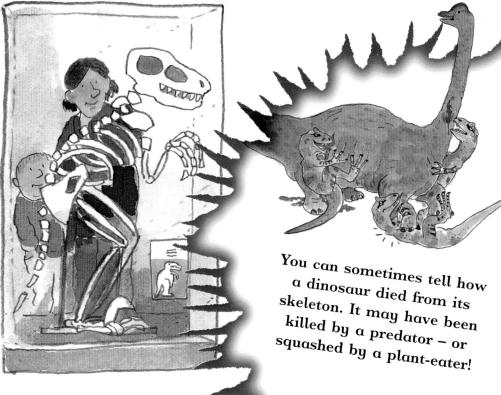

Mammal Hunters

By the end of the Cretaceous Period, mammals had evolved. They looked a bit like modern shrews, squirrels or racoons and were the ancestors of all modern mammals – including us! They are insects, plants and eggs and mostly came out at night when there were fewer dinosaurs around. But there was one hunter still lurking – *Troodon*.

Troodon

Troodon had huge eyes for seeing in the dark. It could move as quietly as a cat and spring upon its prey with slashing claws. Imagine Troodon has scratched a hole in a mammal's burrow and test its reactions!

You will need:

- · an old sock
- two buttons
- needle and thread
- a long cardboard tube
- · a 'mouse'
- cotton or fishing wire

Make a *Troodon* glove puppet with a sock and sew on two buttons for eyes.

Cut two pieces of cotton or fishing wire, they should each be about 15 cm longer than the tube.

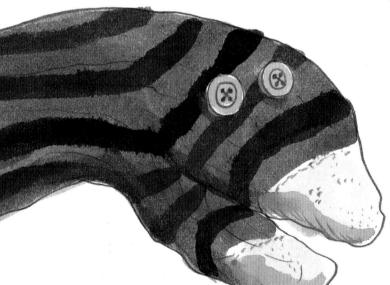

Carefully cut a gap in the tube, 15cm long and wide enough to fit your hand in.

Find a 'mouse' (such as a pet's toy) or make one yourself from two scraps of fake fur material, or a small sock stuffed with cotton wool. Make sure it fits easily through the tube. This is your 'mammal'.

Secure the threads to the front and back of your mammal. Put your mammal in the tube, with the threads hanging out either end.

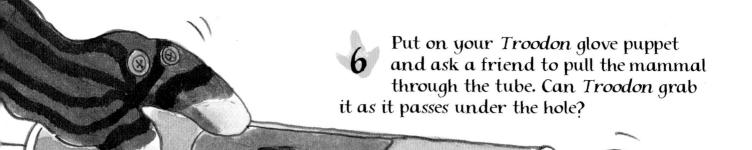

Write a Story

We were safe in our burrows by day.

But after sunset, when we went out
to find food, the night prowlers
would be waiting. I was clever, I
even stole eggs from the prowlers'
nests! But one night my friend
sniff and I made a mistake - we
ran the wrong way! With a hungry
squeal, Troodon cornered us
against a rock. It lashed its tail
and hissed, ready to spring.
Suddenly...

Imagine you are a small mammal living in those long-ago times. Here's the beginning of a story. Carry it on and choose a good ending!

What might happen next:

A T. rex, woken up by the noise, grabs the Troodon and you escape.

B You escape but leave your tail behind in *Troodon's jaws!*

C A volcano erupts and in the panic you dash between *Troodon*'s legs for freedom.

D Sniff doesn't make it!

E None of the above - you've got a better idea.

An early mammal would have looked like this.

39

The End of the Dinosaurs

About 66 million years ago, disaster struck. There was a huge explosion and for many years, clouds of dust in the sky blocked out the sun, rain turned acid and soil and water were poisoned. The climate changed and the food chain was broken. The dinosaurs began to die...

You will need:

- a plastic pop bottle (don't use glass!)
- Bicarbonate of soda or baking powder
- tomato ketchup
- vinegar
- a cup
- sand

Make a Volcano

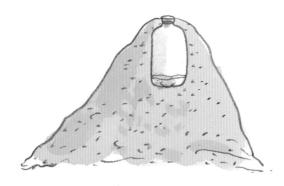

Next mix 4 tablespoons of ketchup with 6 tablespoons of vinegar in a cup

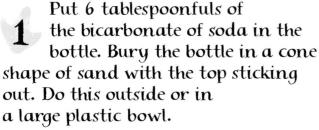

Place your dinosaur models around the volcano.

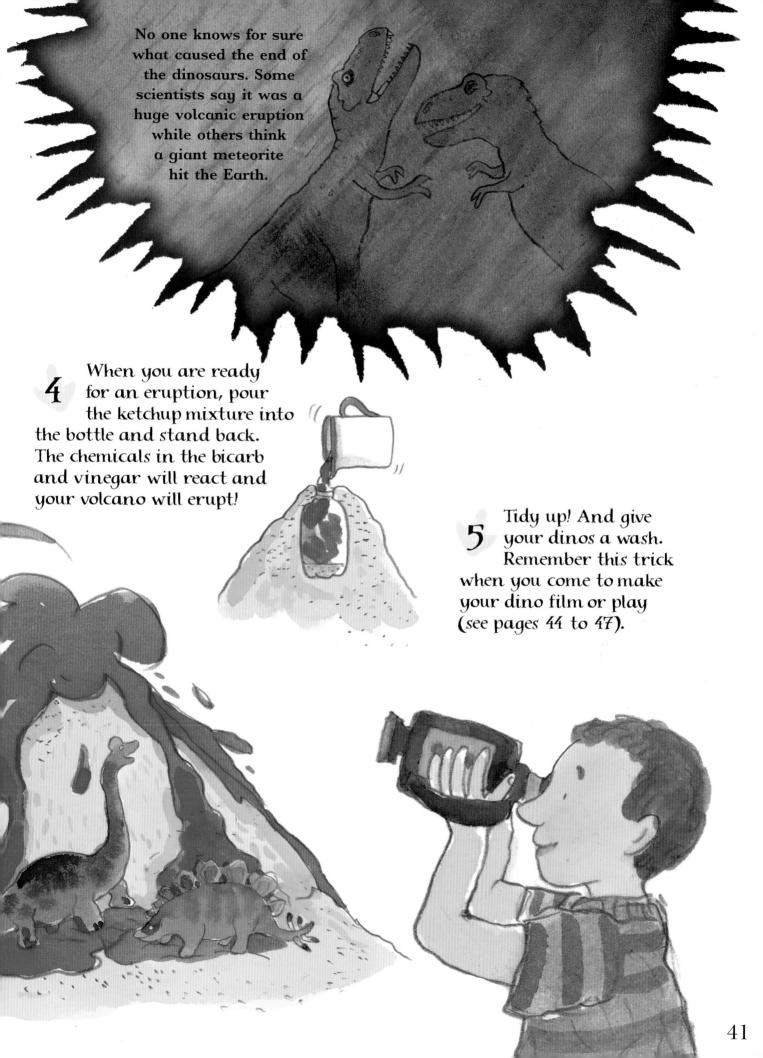

Dinosaur Sunset

In the late Cretaceous Period, there would have been spectacular, very red sunsets.

This was because of all the dust in the air.

Paint your own Cretaceous sunset.

You will need:

- white paper
- black paper
- paints and paintbrush
- scissors
- glue

• sponge

Take a sheet of paper and splodge red, yellow and orange paint on it.

Now fold or scrunch it up to create a crazy, sunset effect. Flatten out

the paper again and leave to dry.

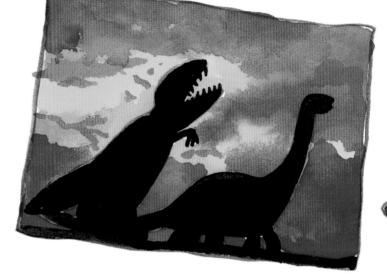

Stick the shapes on your scene.

Alternatively, use the dinosaur-shaped holes left in the black paper sheet as stencils. Stencil them with blue paint,

using a sponge. Wow!

Draw dinosaur shapes on black paper and cut them out.

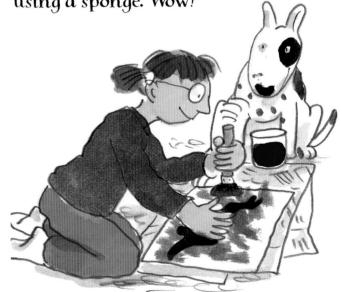

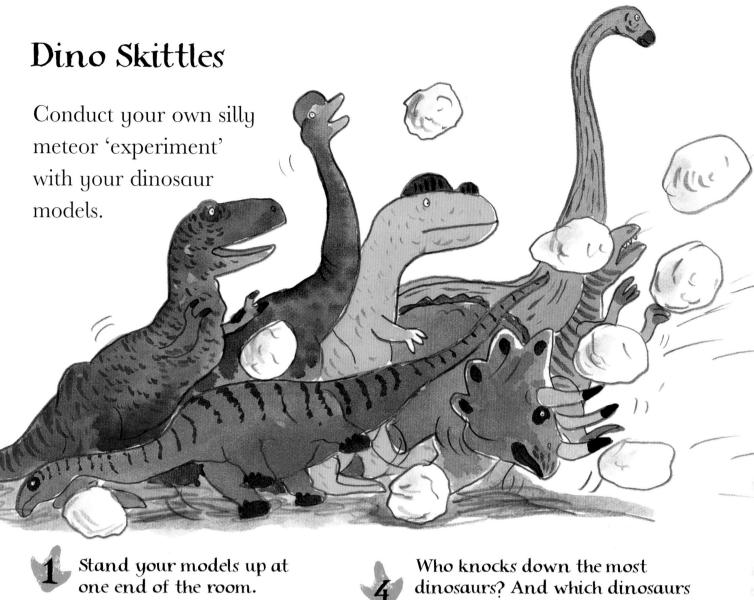

Screw up newspaper into balls (about tennis ball size).

survive and which become extinct in your shower of meteorites?

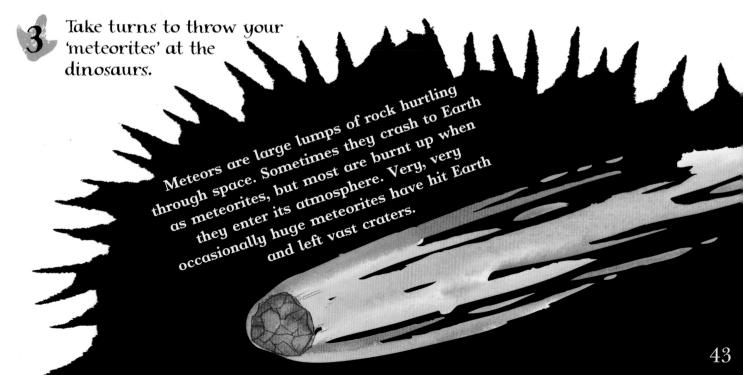

Dino Performances

Part of the fun of being a dinomaniac is sharing your interest with all your friends and family. Here are some ideas of how to put on a dinosaur show. If it's a success, you can turn it into a movie!

• Raptors versus Triceratops

A Dinosaur Play

Using the costumes you have made you could put on a dinosaur play. Alternatively, put on a puppet show set in one of your dinosaur habitats.

Make up your own stories – they can be serious or funny. Make sure they are action-packed! We've given you some ideas to get you started.

• A dinosaur in my bedroom

• Lost in the midnight forest

• A Parasaurolophus egg hatches

Sounds in the Dark

Prepare these sound effects.

A bucket with 3 cm of water in it for splashy sounds.

A sheet of cardboard or hardboard to wobble - and make a thunder sound.

Dinosaur Dances

Include some music in your dino show and get everyone dancing. Dinosaurs moved in many different ways. Find some music which has fast and slow parts, and noisy and quiet passages. Now move to the music like different sorts of dinosaurs.

Stomp like *Stegosaurus* wallowing in mud.

Spring like a hunting Velociraptor.

A kitchen~roll tube to make loud jungle calls through.

A box full of screwed up newspaper to make rustling sounds.

Now write your own 'radio' story using these four sound effects. Practise your play and then record it on a tape recorder. Alternatively give a 'live performance' where you and your props are hidden from the audience - for example behind the sofa or some curtains.

Make Your Own Dinosaur Video

Put all your dinosaur models, activities and performances together in a crazy dinosaur movie. You could film one of your plays or make a nature documentary. If you don't have a video camera, borrow one but remember to ask first.

Script

Start with your script. It gives instructions to the actors as well as telling the story. A 'dino documentary' story could read something like this one.

Scene 1

Voiceover (whisper): And here we are, hiding in the bushes as the T. rex egg starts to hatch.... (egg hatches and T. rex 'chick' climbs out calling)

T. rex chick: Aaark, aaark Voiceover (whisper): What a magnificent beast.

Voiceover (whisper): T. rex youngsters are hungry T. rex chick: Aaark, aaark

as soon as they hatch.

T. rex chick (louder and moving towards

camera): Aaark, aaark!

Voiceover (whisper, to loud shout of mounting panic): Hang on! It's coming this way. I'm inches from a T. rex, It's really..... AAAAARG!!

(Blood splatters across screen)

Ends.

Decide who is going

to do what in your film. Of course, you can do more than one thing.

You will need:

a director

a camera operator

actors

puppeteers

• sound, light and special effects crew

Silent or Sound

If you want to shout directions while you are making your film then it could be a silent movie. Just turn the volume down when you show it and play atmospheric music instead.

If you want sound, practise your footsteps, splashes, rustling trees and dinosaur calls in advance and plan when to use them as you are filming.

Planning

A storyboard is a picture plan of your film, a bit like a comic strip. It can be detailed or really scribbly, so long as it helps you work out what's going to happen and when.

Plan in close-ups of your own models in your dinosaur park, along with live action scenes on location outside in your costumes.

Use the storyboard with your actors and puppeteers to rehearse all the moves first.

When you've done all the planning and rehearing, you can start filming!

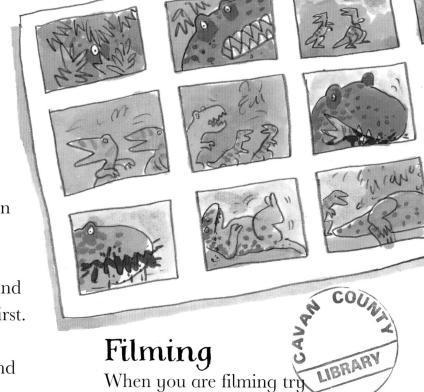

changing the way you look at the action – from a bird's eye view to a worm's. Keep the thing you are filming in the middle of the viewfinder. Make each bit of filming just a few seconds long. Have fun and don't worry if you make mistakes. They can be very funny, too!

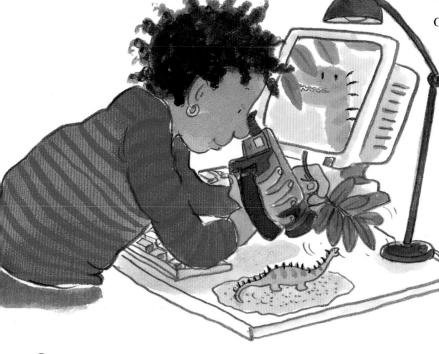

birds~eye

close~up

worms~eye

long shot

surprise

Gore

Finally, make sure there's lots of blood and guts. Use bread soaked in tomato ketchup or maybe cold, ketchup-covered spaghetti!

Dinosaur Index

Allosaurus (all-o-saw-russ) 7, 20, 29, 30 Brachiosaurus (brack-i-oh-saw-russ) 7, 22 Dilophosaurus (die-loaf-oh-saw-russ) 7, 12 Diplodocus (dip-lod-o-kuss) 7, 29, 30 Dromiceiomimus (drome-i-see-oh-mime-us) 20 fossil 11, 28, 29, 30, 33, 34, 36 Giganotosaurus (jig-anno-toe-saw-russ) 21 Ichthyosaurus (ick-theo-saw-russ) 6, 29 Iguanodon (ig-wahn-o-don) 7, 18, 19, 23, 28 Liopleurodon (ly-o-plur-oh-don) 7, 45 Maiasaura (my-a-saw-rah) 14, 15 mammal 38, 39 Ornithocheirus (orn-ith-oh-ky-russ) 6, 16, 17, 45 Oviraptor (ove-i-rap-tor) 6, 14 Parasaurolophus (para-saw-row-loaf-uss) 7, 14, 18, 35, 44, 45

Plesiosaurus (please-ee-oh-saw-russ) 6 Protoceratops (pro-toe-serra-tops) 6, 14, 30 pterosaur (terr-oh-sor) 16, 19, 31. See also Ornithocheirus and Rhamphorhynchus. raptor (rap-tor) 24, 25. See also Oviraptor and Velociraptor. Rhamphorhynchus (ram-for-ink-us) 16, 17 Stegoceras (steg-oh-see-rass) 23, 31 Stegosaurus (steq-oh-saw-russ) 6, 23, 24, 26, 32, 45 *Triceratops* (try-serra-tops) 6, 19, 23, 24, 27, 28, 30, 34 *Troodon* (troo-o-don) 7, 38, 39 *Tyrannosurus rex* (ty-ran-oh-saw-russ rex) 7, 18, 19, 20, 30, 35 Velociraptor (vell-oss-ee-rap-tor) 7, 18, 19,

For Charlottesaurus

First published in 2001 by Franklin Watts, 96 Leonard Street, London EC2A 4XD This edition 2002

Franklin Watts Australia 56 O'Riordan Street, Alexandria, NSW 2015

Text and illustrations © 2001 Mick Manning and Brita Granström

Editor: Rachel Cooke; Art director: Jonathan Hair; Designer: Matthew Lilly; Consultant: Dr David Norman, Sedgwick Museum, University of Cambridge A CIP catalogue record is available from the British Library.

Dewey Classification 567.9

ISBN 0 7496 3873 7 (hardback) ISBN 0 7496 4704 3 (paperback)

Printed in Hong Kong/China

20, 28, 30, 35, 45

Mick and Brita would like to thank Invicta Plastics Limited, Oadby, Leicester for supplying samples from their Natural History Museum Collection (© Natural History Museum, London). The collection, produced under licence by Invicta Plastics Limited, is based on a series of 1:45 scale models authenticated by the Natural History Museum, London and is available from natural history museums world-wide.